Marc Chagall

Christopher Wynne

D1151257

Prestel

Munich · Berlin · London · New York

Chagall's Artistic Roots

Marc Chagall's brightly coloured canvases of fairy tale scenes, mysterious dream-like sequences and surrealist fantasies are familiar to many. But he was much more than an exceptional painter and graphic artist: he was also a designer, sculptor, ceramist and writer. Chagall produced a vast œuvre and continued working right up to the day of his death, creating literally hundreds of etchings, lithographs and ceramic pieces in addition to his paintings, and designing stunningly beautiful stained-glass windows in his typically vibrant palette of colours.

Although Chagall's life spanned a period of immense historical importance, the artist's main inspiration came from his Jewish inheritance and from his immediate surroundings. He adapted elements of artistic movements he encountered to suit his own unmistakable style, regardless of the medium, or rejected them entirely, emerging as one of the most important and prolific artists of the twentieth century.

The Jewish ghetto _ The night Marc Chagall was born was a dramatic one. It was 7 July 1887 and a devastating fire was raging through the Jewish quarter of Vitebsk, a town in Belorussia not far from the Polish border. His mother often told the story of the horrendous scene that night: the houses of most poor families in that part of the town were built of wood. As the flames came closer, Chagall's mother was carried out of the house on her bed, babe in arms, and taken to a safer place in another part of town. Stories such as this made a lasting impression on the young boy who, throughout his artistic career, drew on Vitebsk and his childhood memories for many of his motifs.

Chagall's father, Sachar, worked as a fishmonger's assistant, heaving barrels of salted herring around from morning till night, while his

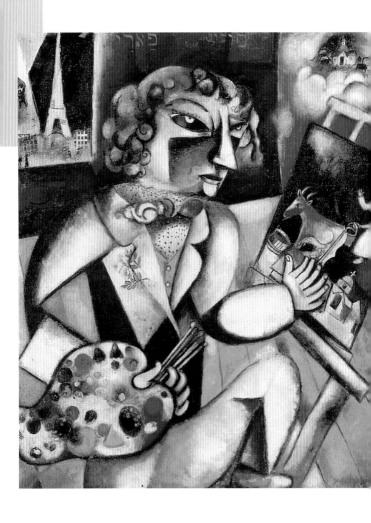

An artist's dream come true: Chagall in Paris

Self-Portrait with Seven Fingers (1912–13),
oil on canvas, 128 x 107 cm, Stedelijk Museum, Amsterdam

Chagall's parents Sachar and Ita-Feiga

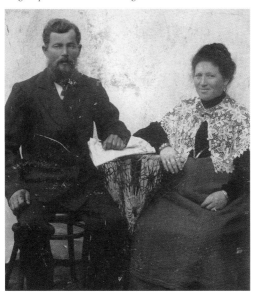

mother, Ita-Feiga, ran a small shop to help supplement their income. He was the eldest of nine children and had one brother and seven sisters, the youngest of whom, however, died in childhood. They lived in cramped conditions in a modest, single-storey building "with crooked shutters and a roof of shingles." Half a dozen uncles, aunts and their families lived in Vitebsk and there was always something going on in and around the house.

He grew up in a simple but loving environment and was closely attached to both his grandfathers whom he visited frequently. One was a teacher of religion and the other a Jewish butcher in Liozno, a village some forty kilometres from Vitebsk. His parents were deeply religious and his father used to rise at six every morning and go to the synagogue before work. As Chassidic Jews, they believed that God was embodied and present in every manifestation of life on earth. The Jewish ghetto fascinated Chagall. He was a dreamer who never failed to see the magic in his environment and strove to reflect this in his paintings.

Childhood days

Marc Chagall as a schoolboy in Vitebsk, *c.* 1897

First art lessons _ As a young boy he attended the *cheder* – the traditional Jewish primary school – but later he went to the local Russian school where he excelled in geometry and drawing and dreamt of becoming an artist. At the age of nineteen, Chagall started to train as a painter at an art school run by Yehuda Pen in Vitebsk, but left after just three months as he felt the teaching was too restrictive. Even at this early age, his spirit yearned to be free. It was also at this time that he started an apprenticeship at a photographer's, earning his keep by retouching photographic negatives. But all the time he really wanted to paint. Together with Viktor Mekler, the son of wealthy Jewish parents and a student at the same art school, he left Vitebsk in the winter of 1906/7 and went off to St Petersburg.

Poverty, patrons and prospects _ Tzarist laws were strict. No Jew was allowed to stay in the capital unless he was a skilled worker, had an academic profession, or was employed in a wealthy person's household. To qualify for a resident's permit in St Petersburg, Chagall acted as a representative for a merchant from Vitebsk before working

once again at a photographer's. This was a particularly testing time for the young, ambitious man. With very limited financial means he could only afford to rent a corner of a room and even had to share a bed. Without a school-leaving certificate the doors to state run academies remained firmly shut. After failing the entrance exam to Baron Stieglitz's school of applied art, he trained to be a sign painter but failed the final exam there, too. Eventually he was accepted at the 'Imperial Academy for the Advancement of the Arts', run by Nikolai Roerich, a well-known stage designer. Things then started to look up. Chagall was awarded a grant of fifteen roubles a month and, as a student, was exempt from military service.

In 1908 Chagall left the academy after a disagreement with one of his teachers and, through a chance encounter, he was admitted to the Svantseva School run by Léon Bakst. With fees of thirty roubles a month – a considerable sum for a poor art student – Chagall worked hard and shared a studio with Vaslav Nijinsky, who went on to become a world-famous ballet dancer, and Vera Tolstoy, the daughter of the author of *War and Peace*. Bakst's school was one of the most progressive and liberal in Russia and Bakst himself a highly acclaimed artist.

Surrounded by relatives

The Chagall family (Marc: second from right in back row), *c.* 1908/09

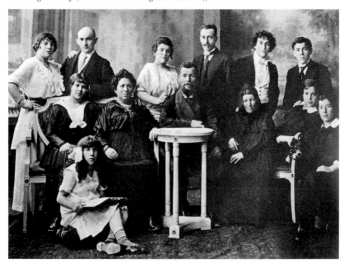

Subdued colours in Chagall's early works

View from the Window in Vitebsk (1908), oil on canvas mounted on cardboard, 67 x 58 cm,
Sinaida Gordejewa Collection, St Petersburg

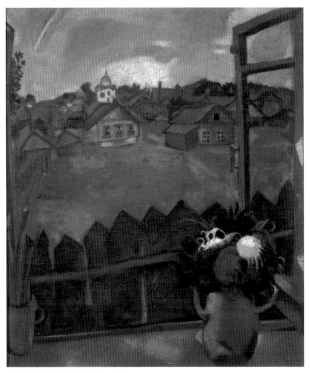

During Chagall's time at this school he gained a new patron – a
lawyer called Goldberg, who took him on as a member of his house-
hold staff and in whose residence he continued to live for some time.
Goldberg introduced him to a number of salons frequented by Jewish
intellectuals and collectors. One introduction was to prove extremely
important to the aspiring artist: in 1909, he was brought to the atten-
tion of the politician Max Vinaver and it was in this circle that Chagall's
talent as an artist was first recognised.

A personal style emerges _ Whenever possible, the young art stu-
dent made his way back to Vitebsk. In this familiar environment, Cha-
gall felt a great inspiration to paint – and he could paint what he liked.
His pictures from this period show that a distinct artistic language was

Portrait of Chagall's Father (1914), tempera on paper mounted on cardboard, 49.4 x 36.8 cm, State Russian Museum, St Petersburg

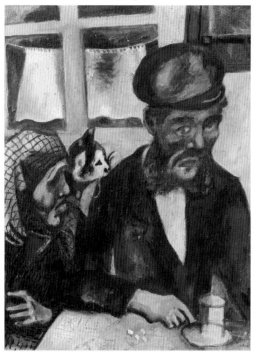

emerging – thanks to his mastery of certain painting techniques – and hints of the motifs and expression of his later works can be detected, although his palette was still remarkably subdued. He painted on coarse sacking, choosing mainly browns, ochres, greens and blues – the colours he could see around him, there being little greenery and few flowers in Vitebsk. Chagall's exuberant, colourful paintings in his unmistakable personal style were soon to follow.

Romance and dreams _ During one such visit to Vitebsk, Chagall met Bella Rosenfeld. Bella, the daughter of a rich and influential jeweller in the town, and Marc, from a poor working-class background and six years her senior, fell in love. Several years were to pass, however, before they were to see each other again. Bella had to go back to Moscow where she was studying at one of the best drama schools in

A day of rest in the Chagalls' house

The Sabbath (1909–10), oil on canvas, 90 x 95 cm,
Museum Ludwig, Cologne

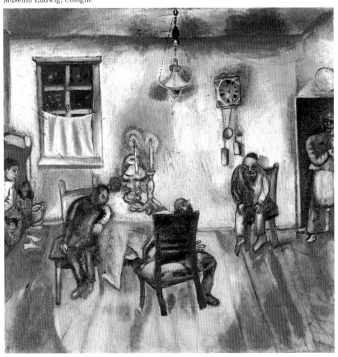

the city and Chagall returned to St Petersburg, hoping to accompany
Bakst to Paris as his assistant. When nothing came of this, Chagall
turned his back on Russian art schools and, with Vinaver's generous
support, headed for the French capital on his own. "I came to Paris
as though driven by destiny," he recorded later. "My art desired
Paris as a tree desires water." It was August 1910 and both Vitebsk
and Bella were now a long way away.

Paris: the metropolis of the intellectual and artistic world and
a dream come true for Chagall. After a four-day journey he arrived
in the city on the Seine with high expectations. Following an initial
bout of homesickness he soaked in the atmosphere of the city and
was inspired by everything he saw: "I did not seek instruction from
academies or teachers. I found it in the city itself."

Famous faces and names _ Chagall moved into a studio in the Impasse du Maine, studied the old masters in the Louvre and the works of contemporary artists in the galleries. He came across the paintings of the Fauves artists and the Cubists, came face to face with the pictures of Fernand Léger and Pablo Picasso and was introduced to Robert Delaunay and his Russian-born wife Sonia. Robert was a great encouragement to many young, aspiring painters and became the mentor of such diverse characters as Paul Klee, August Macke and, ultimately, Marc Chagall.

The Fauves _ The 'Wild Beasts' was a term coined by a French art critic to describe a group of young painters who first exhibited their work together in Paris in 1905. This nickname came from their 'wild', non-realistic use of pure colour, their rather crude simplification of line and their spontaneity of expression. The Fauves owed much to Post-Impressionists such as Paul Gauguin and Vincent van Gogh and to the painting of the Nabis. The original members of this group included Henri Matisse, André Derain, Albert Marquet and Maurice de Vlaminck, but the term was later applied to other artists.

'Singing colours' _ In the winter of 1911/12, Chagall moved into La Ruche ('The Beehive'), the legendary studio complex for painters, sculptors, poets and bohemians. With almost 140 rooms, the twelve-sided building was a melting pot of artistic genius, a place of in-spiration and a source of contacts for artists from around the world.

Chagall's neighbour was Amedeo Modigliani and he soon met many others including the Jewish painter Chaim Soutine, Léger, and the poets Guillaume Apollinaire and Blaise Cendrars. Swiss-born Cendrars was to become a close friend. It was Cendrars who often invented imaginative titles for Chagall's paintings and it was here at La Ruche that Chagall painted the most famous of his pre-war pictures such as *The Fiddler* and *I and the Village* (see p. 17 ff). As Chagall said himself, it was in Paris that "the colours began to sing for the first time."

Happy memories of his homeland

The Fiddler (1912–13), oil on canvas, 188 x 158 cm,
Stedelijk Museum, Amsterdam

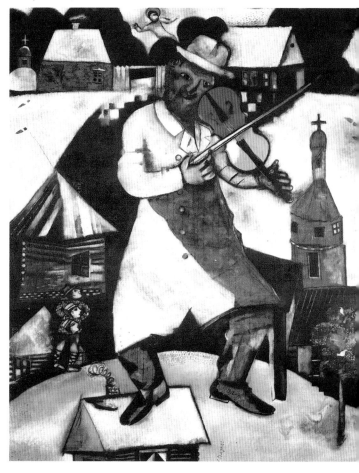

Paris salons _ Chagall submitted three paintings to the Salon des
Indépendants in spring 1912 and was invited to exhibit at the Salon
d'Automne. At the same time other works were being shown in exhibi-
tions in Amsterdam, St Petersburg and Moscow. The following year
he again took part in the Salon des Indépendants but, as on the pre-
vious occasion, failed to sell any paintings. Nevertheless, Chagall had

acquired a degree of artistic confidence as demonstrated in several striking works from this period including *Self-Portrait with Seven Fingers* (see p. 5) and *Paris through the Window*.

Berlin and international recognition _ Through Apollinaire, Chagall met the German collector and gallery owner Herwarth Walden in 1913. Walden invited Chagall to exhibit at the 'Erste deutsche Herbstsalon'

The horrors of war

The Wounded Soldier (1914), crayon, pen and ink and wash on paper, 23 x 13.5 cm (oval), Tret'yakov Gallery, Moscow

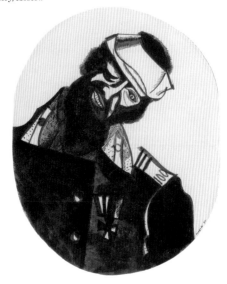

14

Paris through the Window (1913), oil on canvas, 135.8 x 141 cm,
Solomon R. Guggenheim Museum, New York

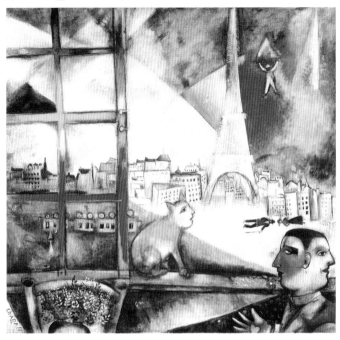

(First German Autumn Salon) held in his gallery 'Der Sturm' in Berlin.
It was here that Chagall gained international recognition and he was
invited to exhibit again in the summer of 1914.

An excited Chagall travelled to Berlin with forty paintings –
virtually all of the important works he had painted in Paris – and
160 gouaches, watercolours and drawings. The exhibition was to prove
a great success. On 15 June, the day after the opening, Chagall set out
for Vitebsk, desperate to see Bella again. He also wanted to attend the
wedding of one of his sisters and spend the rest of the summer in Rus-
sia – but he did not have all the time in the world as his passport was
only valid for three months. That World War I would break out just six
weeks later was impossible for anyone to have foreseen. Chagall was
trapped in Russia and was not to return to Paris again for many years
to come.

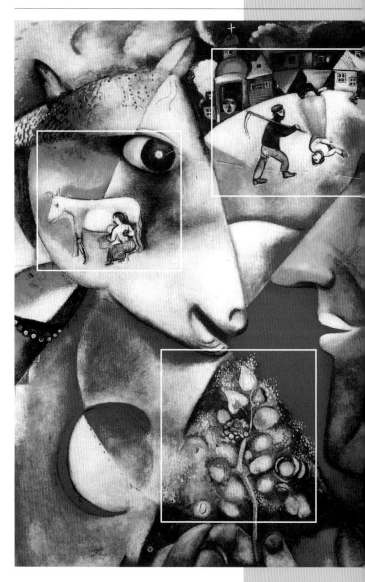

I and the Village (1911), oil on canvas, 192 x 151.5 cm, The Museum of Modern Art, Mrs Simon Guggenheim Fund, New York

I and the Village

The influence of Orphism _ Chagall's painting as a mirror of his childhood memories

Chagall never explained his pictures, but coloured sketches and different versions of the same painting give us an insight into how his mind worked. In Paris, he was confronted with many new artistic ideas and adapted these to suit his own style, combining certain elements with memories of his childhood in Vitebsk to produce paintings full of intense colour, complex imagery and powerful expression.

In the case of *I and the Village*, Chagall first divided up the canvas by drawing circles in charcoal. Various segments were created between the intersecting lines which he filled with different colours. Gradually the coloured planes were given a life of their own and were arranged according to the demands of pictorial logic. These transparently overlaid, glowing areas of colour have their roots in Orphism, a type of abstract painting which developed out of Cubism. This term was originally applied to works by Chagall's mentor and friend Delaunay and his wife Sonia to define their use of pure prismatic colours. It was christened by another of Chagall's close friends, Apollinaire, who stipulated that "the works of an Orphic artist must simultaneously give a pure aesthetic pleasure, a structure which is self-evident, and a sublime meaning that is the subject. That is pure art."

But Chagall did not want to leave the coloured segments as they were and developed them into recognisable objects based on memories and his Jewish inheritance. The green face of a man emerged and the head of an animal – half horse, half cow – was added as a counterbalance. The remaining areas were gradually filled with various images or shades of colour, all held together by the original structure of the painting.

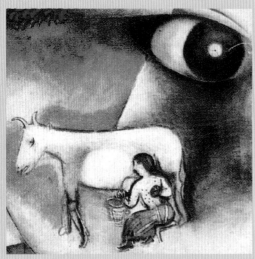

Most recurring symbols in Chagall's paintings, like the bearded man or the cow and the milk-maid, are not related to any particular event, nor do they have any symbolic meaning. Others, however, have a very personal significance: the fiddler, for example, was based on his Uncle Neuch whom he admired very much, and the figure occasionally seen sitting on a roof was modelled on one of his grandfathers who once disappeared during a family gathering. After a long search he was found on the rooftop munching carrots, glad to have got away from the festive commotion below!

I and the Village combines real life with a dream world, fact with fantasy. It made no difference to Chagall whether a person or object was the right way up or not. For him, every element in a painting was essential and could be looked at both individually and as part of the overall composition. His playful imagination let trees blossom in a person's hand and the little wooden houses in Vitebsk dance on their roofs.

18

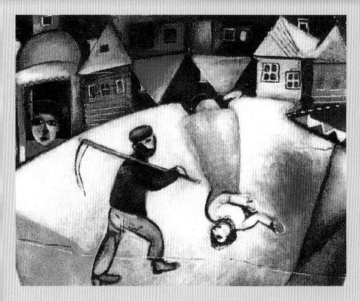

In his parent's house there were no paintings, drawings or prints on the walls in accordance with the strict Jewish interpretation of the second Commandment: "Thou shalt not make unto thee any graven images." Instead there were only a few family photographs and a clock on the wall – another object that frequently appears in his paintings, together with cockerels, a great fiery bird, festival candles and circus acrobats, to name just a few. His parent's house, the street corner, the market place in Vitebsk, the town's thirty odd churches, synagogues, cemeteries and numerous bridges were all included in his work regardless of whether he was living in Germany, America or France. In this respect the title of this work, *I and the Village*, says it all.

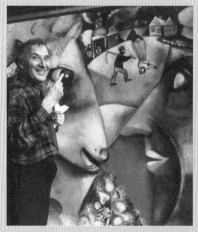

Marc Chagall in front of
I and the Village, Orgeval, 1948

The Russian Years

Love and war _ Marc and Bella married on 25 June 1915. Although Bella's parents had initially opposed their daughter's marriage to someone from a working-class background, they had by now grown to like the young artist. This newly gained happiness, as well as his memories of Paris, are clearly reflected in Chagall's paintings from this period. Their colouring is calmer, their mood exuberant. He produced a series of pictures in which couples float in the air as if swept off their feet by the power of love, as in *The Birthday* (see p. 22). Chagall's works were attracting greater attention, too, and earlier that year, he had been invited to exhibit twenty-five works at the Moscow Art Salon. This was the first major display of his paintings in Russia – and over the next few years he would be asked to contribute works to a number of different exhibitions in both Moscow and Petrograd – as St Petersburg was called between 1914 and 1924.

In the meantime Chagall and his wife had moved to Petrograd. He was called up for military service but was fortunate to have been taken on by Bella's brother, Yakov, as a clerk in the war office in the city. This meant that he could be near Bella and had enough time to paint. Few of his paintings from this period show outward signs of the dangers and horrors of the war, but a number of his drawings depict bandaged soldiers and wounded figures with haunting facial expressions (see p. 14). Considering the extreme conditions under which Chagall and his wife were living, it is interesting to see how rarely Chagall alluded to this directly in his imagery. Such scenes would only be found again in his work later in the century when the artist and his family had to flee the atrocities of World War II.

In the spring of 1916, Bella gave birth to a daughter, Ida. Chagall's love for his family and his unrelenting faith gave him great strength to continue working and he often included his wife and daughter in his

Success comes his way

Marc Chagall, *c.* 1918

The Birthday (1915), oil on canvas, 80.5 x 95 cm, The Museum of Modern Art, New York

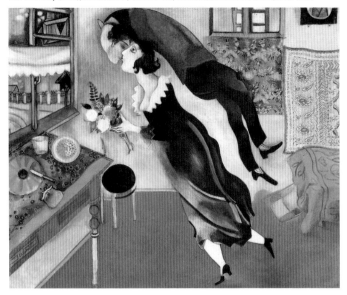

paintings. His works were being shown at an increasing number of venues and in greater numbers, too. Collectors were beginning to show interest in this unconventional artist and critics were already describing him as one of the leading artists of the younger generation.

New opportunities in a new Russia _ In October 1917 the Bolshevik Revolution broke out. Chagall was not interested in politics, but felt a certain relief when the Tzar and his government were removed from power. Under tzarist rule, discrimination against Jews had been severe and now Chagall hoped that his country would become more liberal. A Ministry of Cultural Affairs was established and, much to Chagall's surprise, he was asked if he would take charge of the fine arts division. Upon his wife's advice, who felt that it would distract Chagall too much from his work, he turned the position down and the Chagalls returned to Vitebsk.

The following year was more peaceful and conducive to work. The first monograph on the artist's work was published and Chagall's wish to establish a school of fine art in Vitebsk came one step closer to

reality when approval was given by the Minister of Education and Culture, Anatoli Lunacharsky, who had visited Chagall's studio in Paris before the War. On 12 September Chagall was appointed Commissar for the arts in Vitebsk. This meant that he was also responsible for theatrical productions in the region, much to his wife's particular pleasure. To celebrate the first anniversary of the Revolution on 16 November Chagall mounted an exhibition of works by Vitebsk artists and organised for the whole town to be decorated. A jury was appointed to select the best designs, the streets were adorned with brightly-coloured flags and posters, and banners with illustrations of Chagall's animals were paraded through the town. Everybody joined in the celebrations, but the Party Officials were suspicious and started questioning Chagall's style of painting. His works were too colourful and made no political statement. "Why are your cows green?" he was asked. "And what has all this got to do with Marx and Lenin?"

The focus of his love: Chagall's wife and daughter

Double Portrait with Wine Glass
(1917), oil on canvas, 234 x 135 cm,
Musée national d'Art Moderne,
Centre Georges Pompidou, Paris

Chagall, Bella and Ida, 1917

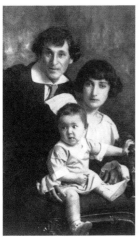

Interior with Flowers (1917), oil on paper on cardboard, I. Brodsky Museum, St Petersburg

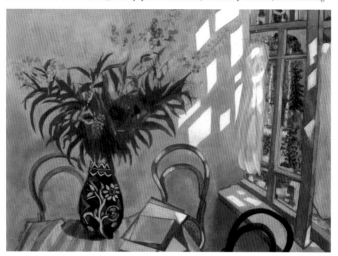

Suprematist power struggle _ Chagall pushed ahead with his plans. A building was made available for use as a museum and art school and on 28 January 1919 the academy was officially opened. It flourished. There were soon 600 students and Chagall took on several new lecturers including his former teacher, Pen, and the well-known artists Kasimir Malevich and El Lissitzky. From April to July that year, Chagall was included in a monumental exhibition of works by 359 artists held in the Winter Palace in Petrograd. He was given the place

Suprematism _ A term coined around 1913 by Kasimir Malevich for a form of art devoid of all representation, expressing itself purely through geometrical shapes and colours. For Malevich, art had to be forward looking and not a continued development of old art forms. His famous work *Black Square on a White Ground* was the first Suprematist work. This movement influenced a number of Russian artists at that time including Aleksander Rodchenko and El Lissitzky and, in the 1920s, it had a strong impact on architecture, textile design and graphic art.

. . . and of his homeland

The Grey House (1920), oil on canvas, 68 x 74 cm, Museo Thyssen-Bornemisza, Madrid

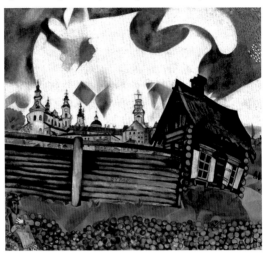

of honour and fifteen of his larger paintings and many of his drawings were shown in the first two rooms. Not only was he praised by the critics, but the State acquired twelve of his works, marking Chagall's greatest public success to date.

This success, however, was soured by a conflict in late autumn stirred up by the radical reformers Malevich and Lissitzky which split the academy into two factions. Malevich pronounced that Suprematist painting was the only possible means of expressing political change on the scale experienced in Russia. For Chagall, who had invested a lot of time and energy in the academy and was well liked and respected by the students, the situation became increasingly intolerable. He had been travelling a lot in search of new ideas and in a tireless effort to promote the arts, leaving little time for his own work. Eventually Chagall resigned from his position on 1 May 1920 and went to Moscow with his family.

Theatrical interlude _ Hard times followed. The financial situation of avant-garde artists in general had worsened considerably and the familiar struggle to find accommodation and food started all over again. They rented one furnished room after another, unable to settle anywhere and Bella was arrested for selling her jewellery at a street

market in an attempt to raise money. During this bleak period Chagall tried repeatedly to obtain permission to return to Paris, but to no avail.

Then, in November 1920, an exciting opportunity arose for Chagall to work in the theatre. He designed sets for the opening production at the new Jewish State Theatre and created huge canvases to decorate the building, including the multifaceted masterpiece *Introduction to the Jewish Theatre* (see p. 29 ff). The overall effect of Chagall's works around the theatre walls evoked strong reactions from the public ranging from bewilderment to praise, from dismay to amusement and led to differences with the theatre director, Alexis Granovsky. Chagall was not commissioned to carry out any further work and was not even paid for the work he had completed.

Death in Vitebsk _ The situation for Jews was becoming increasingly difficult again. While living in Moscow, the Chagalls heard that the jewellery shops owned by Bella's father had been seized and his bank accounts impounded. Then Chagall received the shattering news of his father's death after being hit by a lorry. Soon afterwards his mother

Prismatic and geometric shapes

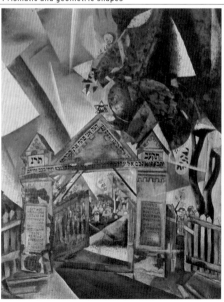

Gate to the Cemetery
(1917), oil on canvas,
87 x 69 cm,
Musée national d'Art
Moderne, Centre
Georges Pompidou, Paris

Firmly rooted in his belief

The Synagogue (1917), gouache, 40 x 35 cm, private collection

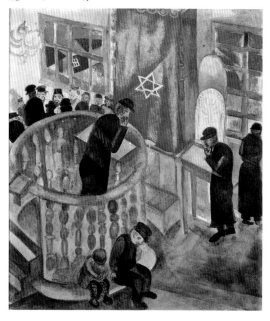

died, too. Due to restrictions imposed on travel, Chagall was refused permission to go to Vitebsk to his parents' funerals. He was extremely embittered and more determined than ever before to reach the West.

Orphans and farewells – Before Chagall's departure, he moved with his family to Malachovka, a respectable suburb of Moscow where, until the Revolution, many wealthy Jewish merchants had had their datchas. Three such villas had been requisitioned for use as an orphanage for Jewish children. It was now 1921 and Chagall was working as a teacher to 120 orphans who had experienced indescribable suffering. He taught them to paint and to perform plays, and he taught them about their Jewish inheritance, but above all he taught them to laugh. Although he received no wages, he and his family were able to live and eat in the orphanage free of charge. Eventually, in the summer of 1922, Chagall left Russia after Lunacharsky had obtained a new passport for him. He would only return to the country of his birth one more time. But until that time, more than fifty years would pass.

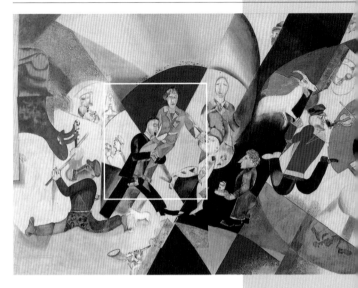

Introduction to the Jewish Theatre (1920–21),
gouache and tempera on canvas, 284 x 787 cm,
Tret'yakov Gallery, Moscow

Introduction to the Jewish Theatre

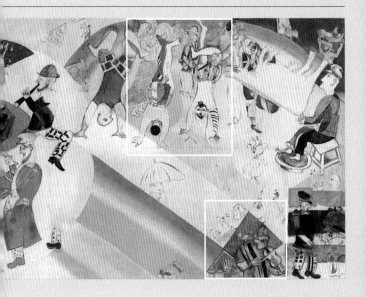

Chagall's vast canvas for the new Jewish Theatre in Moscow _
A combination of different styles and influences result in a dynamic
masterpiece

The theatre was an integral part of Chagall's own life. Several of his
teachers were well-known stage designers and had worked on theatrical
productions. Bella had trained to be an actress and Chagall had already
worked on commissions to paint stage curtains and designs for a number
of lesser-known performances.

The huge canvas *Introduction to the Jewish Theatre*, measuring 284 x 787 cm,
is painted in gouache and tempera. It unites real and imaginary figures,
animals and objects in dynamic, geometrical patterns and interlinking,
coloured planes which captivated audiences at the new Jewish Theatre in
Moscow. It surrounded them with an intensive, orchestrated rhythm
depicting images from both the world of modern theatre and traditional
Jewish life.

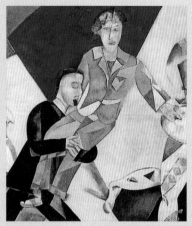

The small theatre in Moscow to be decorated had been created out of a series of reception rooms in a house in the city centre. Jewish intellectuals hoped to establish a new type of Yiddish theatre there that would not just propagate traditional performances of musicals or operettas. As the stage was extremely small, Chagall decided to decorate the whole theatre including the ceiling. Along one wall he created canvases entitled *Drama*, *Music*, *Dance* and *Literature* to fill the spaces between the windows. Above them he added a frieze *The Wedding Feast* and opposite the stage he painted *The Love of the Stage*. The long wall opposite the windows was reserved for his *Introduction to the Jewish Theatre*. The theatre, with a painted surface of 43.5 square metres in total, was officially called 'The Chagall Room' but was soon given the nickname 'Chagall's Little Box'.

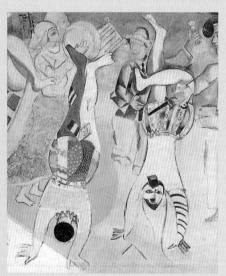

Chagall ignored conventional perspectives, creating a purely two-dimensional plane. With his own poetical sensibility he integrated Cubist and Orphist elements, juxtaposing bold colours and geometrical shapes with Jewish folkloric influences and constructivist tendencies, hinting at the works of Lissitzky and Malevich. The rotating segments and

strips of colour draw the observer's eye from one element to the next and back again. The green cow on the left and its light-coloured counterpart hanging upside-down on the right, mark the beginning and end of this theatrical performance. The figures include actors, musicians, dancers and acrobats, cows, hens and goats, waiters and people in the audience, the director Alexis Granovsky, the intellectual and theatre critic Abram Efros, Bella and Ida, and even Chagall himself.

Efros is depicted in a dark suit carrying Chagall into the world of theatre. To the right of the artist is Granovsky, dancing in mid air. Their surnames are written above them in Hebrew, perhaps a reference to traditional Russian icons or fresco painting. The small figure is an actor in the troupe while the greatest Jewish actor of the day, Solomon Michoels, is portrayed several times as a dancer, flautist, violinist and conductor. The whole canvas is full of tiny details, amusing little anecdotes (such as the man urinating on a pig, bottom right) and Chagall's familiar iconography of hens and wooden houses. The depiction of acrobats reiterates the circus theme and was probably inspired by the men's round dance performed at Chassidic Jewish celebrations – a lively dance that could often lead to cartwheels and headstands. Granovsky appears again on the far right, bathing his feet in a bowl of water. On the left he is the brilliant director, on the right the everyday man, prone to hypochondria.

The metaphors and symbols in *Introduction to the Jewish Theatre* can be interpreted in different ways and on different levels. Chagall, however, was not interested in politics. Instead, the geometric planes, squares, triangles and circular segments, the colours and iconography are intended to sweep audiences into a world of poetry and music, folklore and fiction and transport them into the fantasy realm of the theatre.

Berlin – Paris – New York

Painting in words _ A traumatic discovery _ New inspirations _
The etchings _ The French countryside _ The Promised Land and
other countries _ War and exile

Painting in words _ Chagall's first stop after leaving Russia was Kaunas in Lithuania, where he had been invited to hold an exhibition before continuing his journey to the German capital. Bella and Ida followed shortly afterwards. They stayed in Berlin for a year, living at four different addresses during that time.

Chagall left Russia with a case full of notebooks. Throughout his life he wrote poetry and prose and it was often his gift for words that helped him recreate images in his imagination.

While in Berlin he completed his autobiography but, as fate would have it. it was not to be published until 1931 when it first appeared in French. Much of the writing dated from 1915–16 when he had been working in the war office and had had time on his hands. Since the War, Chagall had met a number of Russian poets and writers, including Boris Pasternak, the author of *Doctor Zhivago*, and the influence of these literary friends contributed to the rather idiosyncratic style of his autobiography.

Wanting to illustrate this poetic narrative himself, Chagall experimented with woodcuts and lithographs before being introduced to the German etcher Hermann Struck who taught him how to work using this complex technique.

A portfolio of twenty etchings was issued in 1923 under the title *Mein Leben* (My Life) and it was these sheets that established Chagall's reputation as a master of his craft, even enabling him to earn a living later on in Paris. Although he did not start etching until he was thirty-five, it is a tribute to Chagall's genius that he was to go on to become one of the foremost exponents of this technique in the twentieth century.

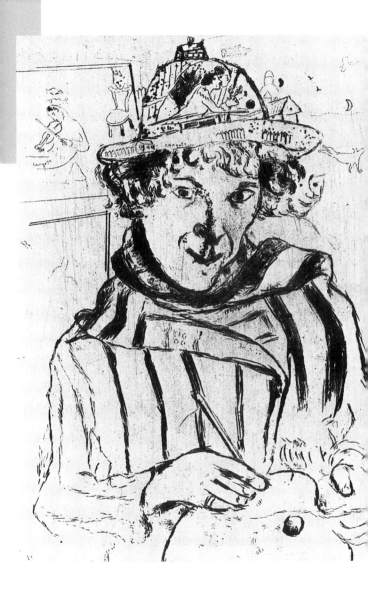

A microcosm on his head

Self-Portrait with Decorated Hat (1924), etching, 20.5 x 14.5 cm,
The Tel Aviv Museum of Art, Tel Aviv

My Village (1923/24), gouache, 48.5 x 62,
Katz Collection, Milwaukee, Winsconsin

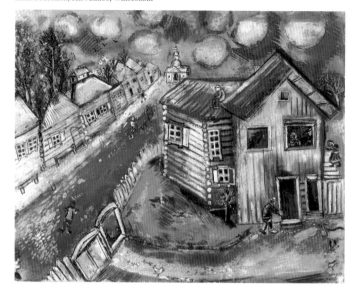

A traumatic discovery _ The forty paintings, gouaches and numerous drawings that Chagall had entrusted to Walden before leaving for Russia in 1914, had since been sold or were no longer in the gallery owner's possession. Chagall had never received any payment; instead he was told that "fame alone must surely be payment enough." Chagall was furious and took Walden to court but his bid was unsuccessful. A settlement was finally reached in 1926 and Chagall regained possession of three of his paintings including *I and the Village*.

During the War and the years that followed, Walden had in fact continued to exhibit and promote Chagall's works and the artist now found that he was surprisingly well known in Berlin. After a couple of successful exhibitions in the city, he felt he could even afford a holiday and took his family off to the Black Forest and later to Thuringia. Upon their return he received a letter from his friend Cendrars saying that the publisher Ambroise Vollard was interested in commissioning Chagall to make book illustrations. Paris was beckoning and Chagall was swift to act.

New inspirations _ In September 1923 the Chagalls arrived in Paris. For the best part of six months, the young family stayed in the run-down Hôtel Médical, a cheap hostelry that took in foreign artists. Chagall had hoped to move back into his studio in La Ruche in which he had left all his works safely locked away – or so he thought. He was devastated to find that the studios had been requisitioned for refugees during the war and all his works had been dispersed. There was nothing he could do.

Paris, however, had lost none of its magic. Chagall wasted no time in renewing his contacts, making frequent visits to the Delaunays and seeking out Bakst and Vinaver who had supported him so generously in the past and who were now living in the French capital. In the following year, 1924, Chagall managed to find a new, spacious studio so the family could at last move out of the shabby hotel. There followed an extensive period of creativity during which he produced an astonishing variety of works ranging from his black-and-white etchings for Vollard to brilliantly coloured canvases.

Back in 1914, his friend Apollinaire had described similar works as 'surnaturel'. There certainly was an undeniable thread of dreamlike, surrealistic imagery running through Chagall's new works, too, and this prompted an invitation from Max Ernst to join the Surrealists. Chagall declined the offer, however, wary of any deliberate involvement with the realm of the subconscious.

. . . and looking ahead optimistically

The Chagalls in their studio home in the rue d'Orléans, Paris (1924)

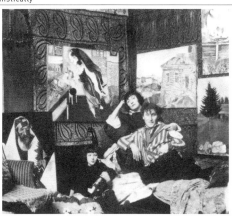

The etchings _ Chagall set to work on his first series of etchings for
Vollard illustrating Nikolai Gogol's *Les Âmes mortes* (Dead Souls), one
of the greatest Russian novels of the nineteenth century that draws
on the magic of Chagall's homeland for its inspiration. Vollard paid
the artist 500 francs for each of the copper plates completed and, due
to this regular income, Chagall was able to concentrate wholly on
this project, completing thirty-seven plates by the end of 1924 and
all ninety-six by the end of the following year.

This was followed in 1926 by etchings for Jean de la Fontaine's
Fables, for which Chagall received twice the amount for each plate.
Vollard's choice of a foreign artist for this seventeenth-century classic
so close to every Frenchman's heart caused quite a stir at that time,
but the publisher was quick to point out that the fables originated
from a number of Eastern and classical sources and were not French
at all. Vollard's support and friendship from 1923 until his death in an
accident in 1939 were of enormous significance. During these years
Chagall worked on two further series of etchings for his patron – the
first focussed on the circus while the second, which was of greater
importance, was a commission to illustrate the Bible (see p. 43 ff).

The French countryside _ Two more moves and several exhibitions
later, the Chagalls spent most of 1926 in the countryside and travelled
extensively throughout France. However, regardless of where he was,
he never ceased to work. Throughout the twenties and thirties Chagall
was constantly on the move, staying in remote areas, exploring the

Chagall's colours become more intensive

Clown on a Horse (1927), gouache, 66 x 50.7 cm, private collection

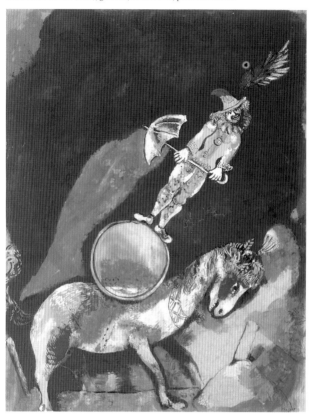

mountains and the coasts, changing studios and moving house. His works were being exhibited in venues across Europe and in the United States and both his fame and popularity increased year by year. Chagall expanded his subject matter and introduced new motifs such as lovers entwined in vibrant colours or bathed in moonlight. Flowers became a dominant feature, while animals continued to hold their own in the dream-like worlds he created. Chagall started to mix oil paint and gouache and experimented with pastels. His techniques varied from thin applications of paint to thick layers that look as if they could flake off the canvas or paper on which they are painted.

The Stroll (1929), oil on canvas, 55.5 x 39 cm, The Rosengart Collection, Lucerne

The Cock (1929), oil on canvas, 81 x 65 cm, Museo Thyssen-Bornemisza, Madrid

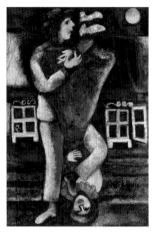 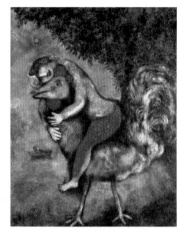

The Promised Land and other countries _ In late 1930 he was asked to contribute to the proposed Tel Aviv Museum and invited to travel to Palestine. Thrilled at the idea, he eagerly took up the invitation and, in February 1931, Chagall, Bella and Ida embarked at Marseilles for the Middle East. This journey was another dream come true. They visited Alexandria, Cairo and the pyramids en route and, on arriving in Haifa, Chagall called on his etching teacher Struck who had emigrated to Palestine some years earlier. He visited Jerusalem

École de Paris _ This term was applied to a number of
styles. Broadly speaking it refers to French and non-French artists living in Paris in the first half of the twentieth century and, more specifically, to painters working in and around La Ruche between 1905–25. These included Modigliani, Soutine, Utrillo and Chagall, who was considered one of the major figures of the École de Paris at that time. Despite different artistic intentions, all the artists worked in a style that could be described as Expressionist in the broadest sense of the word.

and the ancient religious sites, recording many of his impressions on canvas and stayed for a total of three months. The Tel Aviv Museum project sowed the seed in Chagall's mind for the Museum of the Biblical Message in Nice which was to open many years later in 1973.

Other journeys took him to Spain, the Netherlands and England. After receiving an invitation to the inauguration of a Jewish cultural centre in Vilna, Chagall returned to Poland in 1935 and, two years later, he went to Italy with his wife where they marvelled at the art treasures in Florence and Venice.

The power of love

Lovers with Half-Moon (c. 1926–27), gouache, 63 x 40 cm, Stedelijk Museum, Amsterdam

The Bride and Groom with the Eiffel Tower (1938/39), oil on canvas, 150 x 136.5 cm, Musée national d'Art Moderne, Centre Georges Pompidou, Paris

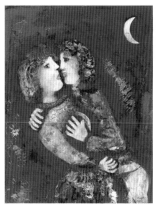 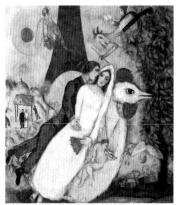

Exhibitions, theatre work, commissions and travel continued to dominate Chagall's day-to-day life. By now his daughter Ida was grown up and, in 1934, she married Michel Gordey, a young lawyer. This inspired him to paint several works related to marriage and love, despite the dark shadow that was being cast across Europe.

War and exile _ Hitler had seized power in 1933, the Spanish Civil War broke out in 1936 and the threat to world stability could be felt everywhere. Chagall and Picasso used to meet several times a month at the Café du Flore in Paris and, at this time, Picasso was working on his monumental painting *Guernica*. While the Spanish artist was passionately concerned about the fate of his homeland, Chagall was

White Crucifixion (1936), oil on canvas, 155 x 140 cm,
The Art Institute of Chicago

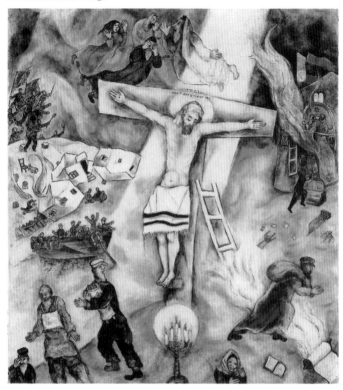

completing *White Crucifixion*, an unusually overt statement depicting
scenes of Jewish persecution at a time when his people were also
facing appalling atrocities. Back in 1933, Chagall had painted *Solitude*
which seems to hint at the threat that was now very real and the
anti-Semitism he experienced first-hand during his visit to Poland.
Chagall had left Russia knowing that he would not have been able to
live there freely and, once again, he could feel the noose tightening
around his neck in the south of France where he was now living.

Despite having been granted French citizenship in 1937, Chagall
was forced to seek asylum in the United States. Having waited almost
too long – and after being imprisoned briefly in Marseilles – Chagall

A foreboding

Marc Chagall painting
Solitude (1933)

left France on 7 May 1941 with his wife and daughter and crossed Spain to Portugal, where they waited for berths on a cargo ship bound for New York. With an invitation from the Museum of Modern Art in his pocket he was much better off than many, but it hurt the artist deeply that, for a second time, he had to flee from a country that he had grown to love.

On 23 June, 1941 Chagall and his family reached the New World.

What will the future bring?

Solitude (1933), oil on canvas, 102 x 169 cm, The Tel Aviv Museum of Art

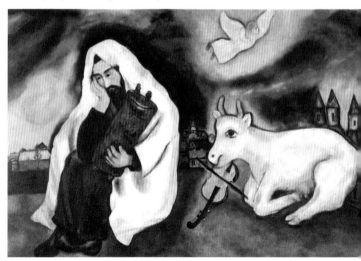

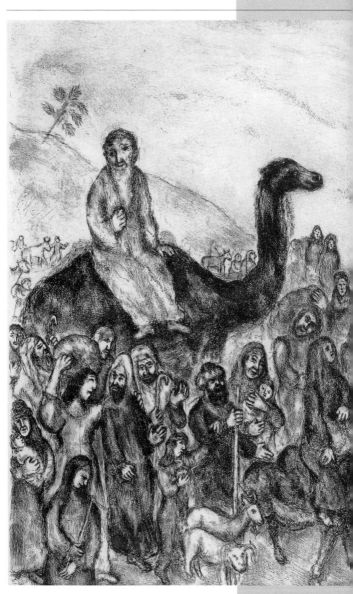

Jacob's Departure for Egypt (sheet 24)

The Bible

Ambroise Vollard as an inspirational friend _ Chagall's modern interpretation of the Old Tesatament

The etchings Chagall made to illustrate the Bible evolved from an idea he had had for the Books of the Prophets which was later expanded to cover the whole of the Old Testament. As a twentieth-century interpretation it is an inspirational work and one which was very close to Chagall's heart. Although the style and imagery is little different from those used by the artist in his other series of etchings, it is precisely this similarity that lends the Bible series its immediate appeal.

In view of his Chassidic upbringing, it may seem unusual that Chagall was prepared to tackle such a sensitive project. But unlike many older Chassidic Jews who believed that painting pictures of God's creations was wrong, Chagall felt that art was a means of praising God's work. Like generations of artists before him, the Old Testament had preoccupied him since his childhood days and many of the images in his biblical etchings originate from his memories in the Jewish ghetto in Vitebsk.

Ambroise Vollard commissioned Chagall to create this series when work on la Fontaine's *Fables* was nearing completion. Chagall returned from his trip to Palestine in April 1931 full of new ideas and started straight away on this major project, basing many of his etchings on the sketches and paintings he had made of various biblical sites in and around Jerusalem, such as Rachel's Tomb or the Wailing Wall.

Chagall's etching techniques vary from unbroken, sweeping curves to dotted lines, and from large white spaces to dense black areas. Chagall used this interplay of light

Rachel's Tomb (sheet 17)

and shadow to best advantage, as shown in *Abraham Entertaining the Three Angels*. This sheet also has elements found in Russian icon painting, whereas other etchings have folk tale qualities and an innocence of style. The imagery is earthly and human in dimension, but the etchings also suggest a certain element of mystery – their luminosity implying that it is more than a merely optical phenomenon.

Before he started on the etchings Chagall made around forty preliminary gouache sketches which, unlike those he produced for *Fables*, are comparatively uniform in their style and execution. Many of the gouaches reflect the vitality of scenes which Chagall remembered from his childhood or which occurred in his dreams and are depicted in the artist's unique painterly language.

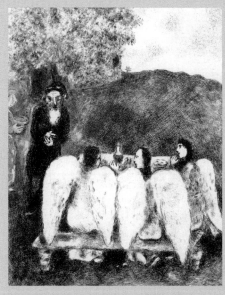

Abraham entertaining the Three Angels (sheet 7)

44

Some of Chagall's series of etchings were produced over a long period, but none was so long as the Bible series. Having started in 1931, he continued until Vollard's death in 1939, by which time he had completed sixty-six plates. None of these works however had actually been printed. The reason for this is quite simple: the eccentric art dealer Vollard, who paid Chagall regularly for each work, kept the copper plates in his cellar where they were found under

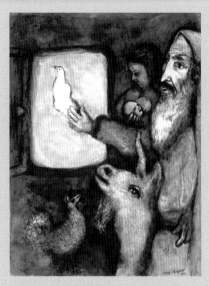

Noah Dispatching the Dove (1931), oil and gouache, 63.5 x 47.5 cm, Musée national Message Biblique Marc Chagall, Nice

layers of dust after his death. The art dealer's primary interest in the etchings was as works of art rather than as a source of income. He collected the plates and furthered the artist's development but was not concerned about turning these works into a profitable venture.

Chagall resumed work on the series in 1952 after a break of thirteen years. He added a further thirty-nine plates to the original sixty-six, completing the work four years later. With a total of 105 plates, the series was published by Tériade, who was also handling much of Matisse's work and with whom Chagall worked on a series of colour lithographs illustrating *Daphnis and Chloe*.

By 1956, when the Bible etchings finally reached a broad public, Chagall's reputation as an illustrator was already firmly established. The craftsmanship and imagination he demonstrated in his etchings of the Bible set him apart from other artists and, today, he is rightfully considered one of the greatest masters of this technique in the twentieth century.

Paradise Lost and Regained

America and its artists _ Familiar faces and the ballet _ Paralysing grief and a new start _ Artistic brilliance returns _ France beckons _ The Côte d'Azur _ New artistic media and a new love _ Vibrant colours _ The lithographs and other projects _ Homeland revisited _ "To live is to work and to work is to pray"

America and its artists _ Picasso, Georges Rouault, Raoul Dufy and Max Ernst also received invitations from the Museum of Modern Art in New York to go to America. The invitation had helped Chagall not only to obtain an exit permit for himself, his wife and his daughter, but also for his paintings which Ida had sent on ahead to Lisbon by train. Although he was now safe in New York, Chagall had heard reports of concentration camps and feared for the millions of Jews who were less fortunate than himself. News had also reached him of his beloved Vitebsk: the town now found itself on the front line and, between 1941–45, it was to be occupied by the Germans and heavily bombed. Chagall found comfort in his painting, producing a number of wintry landscapes and melancholic scenes.

Familiar faces and the ballet _ Chagall set to work on a number of paintings he had started in France. His work was well known in New York and he had a dealer and friend in Pierre Matisse – the son of the French artist – who was willing to show the European's work in his New York gallery. He found life in America difficult and New York overwhelming. Not knowing any English, but speaking French, Yiddish and Russian, he was always pleased whenever he could renew connections with his homeland. Understandably, he was overjoyed when he met his old friend Michoels again, the principal actor at the Jewish State Theatre, who was on tour in New York.

Chagall was invited to work with the Russian choreographer Léonide Massine on the ballet *Aleko* for the New York Ballet Theater. Based on the nineteenth-century poem *Gypsies* by Alexsander Pushkin and

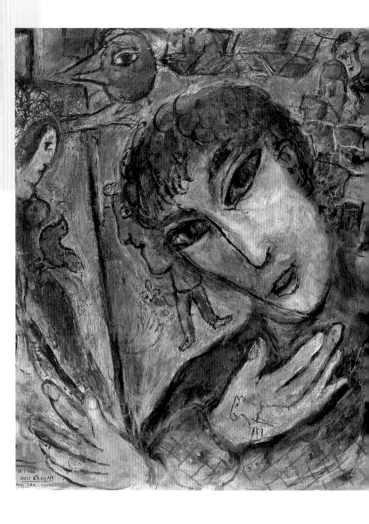

Chagall's characteristic pictorial language

Large Face – Self-Portrait with Large Yellow Face, 1969,
gouache, 63 x 54.5 cm, private collection

War (1964–66), oil on canvas, 163 x 231, Kunsthaus Zürich

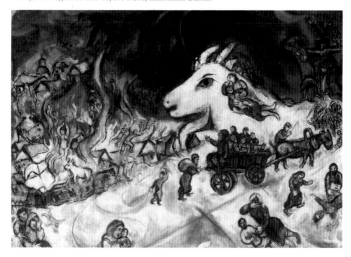

danced to the music of another Russian, the composer Tchaikovsky, this was the perfect project for Chagall. His large backdrops were really more like paintings in their own right and he used colour to great effect, painting for example a view of St Petersburg in shades of grey – underlining the plight of the city under siege by the Germans. In 1943 Chagall and Bella travelled to the première of the ballet which was held in Mexico City. The brilliance of the light and the sun in the south had a positive influence on the artist and on his work.

Paralysing grief and a new start _ The Chagalls spent the following summer at Cranberry Lake in upstate New York, leading a peaceful and contented life. On 2 September 1944, however, tragedy struck. Bella had caught a virus infection a few days earlier and died suddenly. Grief-stricken, Chagall turned the pictures in his studio to face the wall and, for more than nine months, he could not paint at all. "When Bella left this world," he wrote later, "everything went dark before my eyes." For nearly thirty years Bella had been not just his companion and inspiration, she had also been his most perceptive critic.

In the summer after her mother's death, Ida arranged for Virginia Haggard McNeil, a young Englishwoman who spoke French, to look after her father. The following year Chagall and Virginia moved into

a house in the Catskill Mountains and a relationship began which was
to last until 1952.

Artistic brilliance returns _ The New York Ballet Theater approached
Chagall again in 1945 and asked if he would be willing to design
scenery and costumes for *Firebird*, based on old Russian folklore and
danced to music composed by Stravinksy. This commission helped
Chagall recover from his grief and loneliness and, this time, it was Ida
who was at his side to supervise the costumes. Like *Aleko*, *Firebird*
was a great success and, soon afterwards, he set about working on
his lithographs for *Four Tales from the Arabian Nights*. Although
he had experimented with lithography while in Berlin in 1922, it was
not until now that Chagall took up colour lithography, a medium that
enabled his work to reach a wide audience and which contributed
to his immense popularity.

France beckons _ Chagall still dreamt of Paris, "my second Vitebsk,"
as he once called it and, following a major restrospective of his work
at the Museum of Modern Art in New York and in Chicago in 1946,
he travelled to the French capital for a brief visit. The next year he
went back again for a show at the Musée national d'Art Moderne
while important exhibitions were being planned throughout Europe –

In the world of ballet

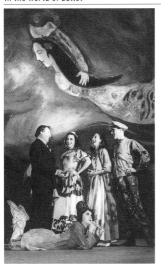

Chagall and four dancers
in front of a backdrop for
Aleko (1942/43)

The Creation of Mankind (1956–58), detail, oil on canvas, 300 x 200 cm,
Musée national Message Biblique Marc Chagall, Nice

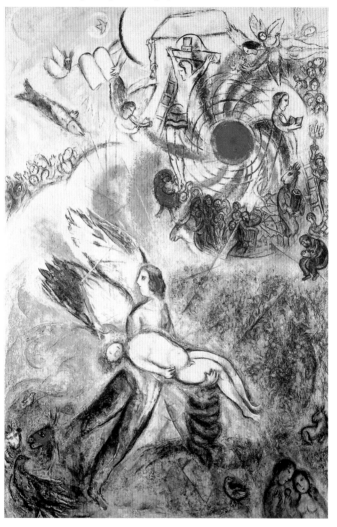

in London, Amsterdam, Zurich, Berne and Venice. In 1948 he returned
to France for good and moved into a house in Orgeval, just outside
Paris with Virginia and their son, David, who was born in 1946.

Mutual inspiration

Picasso and Chagall in the Atelier Madoura, Vallauris, early 1950s

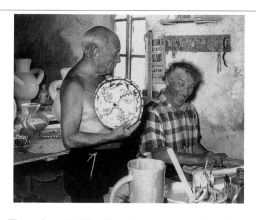

The Côte d'Azur _ Throughout his life, Chagall was constantly on the move, but he was soon to settle down. In 1949, he visited the publisher Tériade in Saint-Jean-Cap-Ferrat in the south of France and, while he was there, Tériade suggested he should illustrate the great master-piece of Hellenistic literature *Daphnis and Chloe*. The countryside and the light cast their magic spell on the artist and, later that year, he was back again. He rented a studio in Vence and produced his first ceramic piece. He returned in 1950 and purchased a property called 'La Colline' (The Hill), just outside the town. The Côte d'Azur had become a centre of art since the war and Chagall often met Matisse and Picasso who lived in the nearby towns of Cimiez and Vallauris.

Chagall's Ceramic Works _ Chagall made more than two hundred ceramic works and sculptures between 1949 and 1962. This medium was already firmly established in the south of France and, from 1951–62, Chagall worked in Vallauris together with Picasso. His pieces range from painted platters, tiles and wall ce-ramics, to thrown vases and jugs that were sculptural in their exe-cution. Chagall also proved his masterly skill in the use of enamel, engobe and terracotta, as well as glazing. The experience Chagall gained working with ceramics was incorporated into his paintings and led him to redefine and restructure the painted surface.

The Cock (1950), wall ceramic (4 tiles), 25 x 27.2 cm, private collection, courtesy Yves Lebouc

Peasant at the Well (1952/53), vase, 33 x 22 cm, private collection

New artistic media and a new love _ This was also a period of experimentation with a variety of new materials. Chagall created hundreds of painted ceramics which he decorated with motifs found in his Vitebsk paintings. "I like handling clay," he once wrote. "It's the most delicate of all materials. I like to be close to the earth." At the same time he carved a small number of sculptures and worked on a cycle of biblical pictures.

The story of the Creation

Life (1964), oil on canvas, 296 x 406 cm, Fondation Marguerite et Aimé Maeght, Saint-Paul

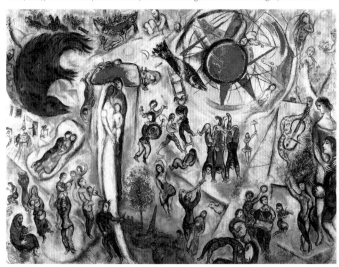

In the fifties he illustrated the *Song of Songs*, an ancient poem on spiritual and secular love – a choice which may have been triggered off by his meeting Russian-born Valentine (Vava) Brodsky in spring 1952, when she was introduced to Chagall by Ida. By this time, Virginia had left Chagall and returned to Paris where Ida herself had now settled with her second husband. On 12 July that year, Chagall and Vava were married. They were to remain together until the artist's death in 1985.

A harmonious marriage

Vava and Chagall
at La Colline, 1962

Vibrant colours _ Chagall continued to paint as well as to experiment with new media, and his subjects still reflected his undying love of the world around him. Like in his earlier works animals flew through the sky and lovers floated in clouds of flowers but his canvases were larger and his colours more vibrant. During this period he started two important series of works, returning once again to familiar themes: one captured the magic of the circus and the second illustrated well-known biblical themes. Some of Chagall's late canvases such as *The Fall of Icarus* (see p. 54) or the powerful depiction of horror in *War* (see p. 48) may be interpreted as a secular counterpart to his biblical pictures. Equally large in scale, their subdued colours seem to capture the fate of modern man.

The Fall of Icarus (1974–77), oil on canvas, 213 x 198 cm,
Musée national d'Art Moderne, Centre Georges Pompidou, Paris

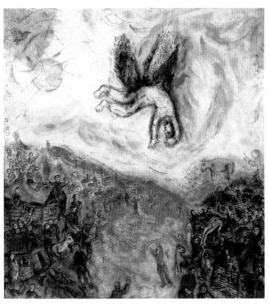

The lithographs and other projects _ Chagall produced around
1,000 lithographs in both black and white and colour during his lifetime.
In 1957, he eventually started working on illustrations for *Daphnis
and Chloe* which are now universally acknowledged as masterpieces
of colour lithography. He also explored mythological subjects and
worked on a monumental mosaic at Nice University entitled *Message
of Odysseus*. At three metres high and almost eleven metres long, it
demonstrates both Chagall's unique skill in handling new techniques
and his daring theatricality. He used these to good effect for a gigantic
ceiling decoration commissioned by the Paris Opéra in 1964 which, in
turn, led to his much admired stage designs for the New York Metro-
politan Opera's production of Mozart's *The Magic Flute* in 1967.

From the end of the fifties onwards, Chagall turned his attention
to stained glass and adapted the ancient technique of painting on glass
before firing, producing around thirty windows in total (see p. 59 ff).
Chagall also designed seven tapestries – three of which are in the

A masterpiece of colour lithography

Spring (1957), colour lithograph
from *Daphnis and Chloe*

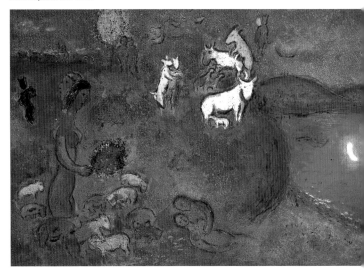

Knesset in Jerusalem – and completed a small number of mosaics.
He wrote about art in Yiddish, Russian and French, published accounts
of his travels to the Holy Land and other countries and brought out
a volume of poetry, *Poèmes*, which was published in Geneva in 1975.

Chagall masters a new medium

Stained-glass window, north transept,
Metz Cathedral, 1963–64

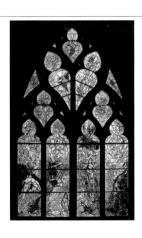

Chagall working on **Daphnis and Chloe**, 1957

Chagall signing his masterpiece **Introduction to the Jewish Theatre**
in 1973, more than fifty years after it was painted

Homeland revisited _ In 1973, two important events took place. In
June, Chagall and Vava went to Russia at the invitation of the Soviet
Minister of Culture. It was an emotional journey into the past: they
visited the Jewish Theatre in Moscow and two of the artist's sisters in
Leningrad, but did not go to Vitebsk. The second event that year was
the inauguration of a new museum in Nice on 7 July. Called the Musée
National Message Biblique Marc Chagall it houses many of the artist's
paintings, sculptures and other works depicting scenes from the Old
Testament, created following Chagall's return from exile in the United
States.

"To live is to work and to work is to pray" _ Despite his old age,
Chagall lived as he had always lived, working hard and travelling
extensively. When he was ninety, he was awarded the Grand Cross of
the Legion of Honour, one of France's most prestigious decorations.
He worked on a stained-glass window for the Art Institute of Chicago
and went to a number of retrospectives of his work, including major
exhibitions in the Louvre and at the Royal Academy of Arts in Lon-
don. These highly acclaimed shows testified to the creative genius of

A demonstration of a deep religious conviction

King David (1951), oil on canvas, 194 x 133 cm,
Musée national Message Biblique Marc Chagall, Nice

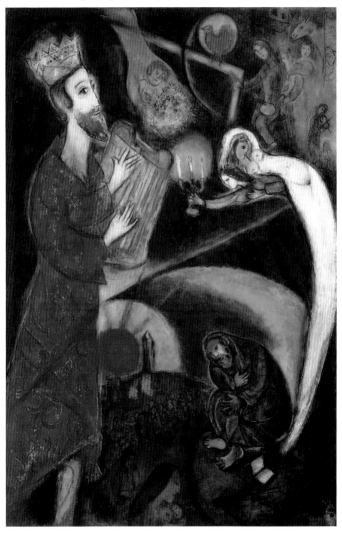

one of the twentieth century's most important and versatile artists.
On 28 March 1985, Marc Chagall died peacefully in Saint-Paul-de-
Vence. He was ninety-seven years old.

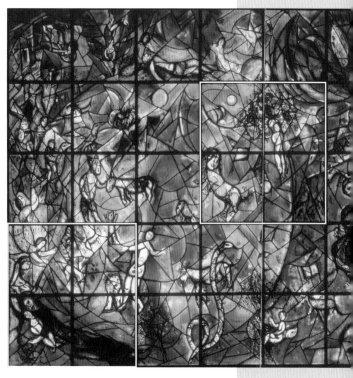

Peace (1964), stained-glass window, 358 x 538 cm,
United Nations Building, New York

Peace

**Medieval stained-glass windows
fascinate Chagall _ Commissioned
by the United Nations**

Stained glass is perhaps the medium best
suited to conveyeng the dream-like
quality of Chagall's work. The exceptional,
expressive character of his windows
with their mass of symbols and brilliant
colours are arguably the most stunning
works in stained glass created in the
twentieth century.

Chagall was deeply moved when he first
saw the medieval stained-glass windows
in Chartres Cathedral. He was intrigued
by the play of light and colour and felt it
was a medium that could equally well
be used for both secular and religious
subjects. When Chagall first moved to the
Côte d'Azur he was in close contact with
Picasso and Matisse. Between 1948–51
Matisse was working on his window
designs for the Chapel of the Rosary in Vence which the artist himself
described as "the culmination of a life of work." Chagall felt inspired to
experiment in this medium and a new, highly creative period began,
during which he worked with great vigour on the designs of a large
number of windows in which his intensive colours merge with his mystical,
dream world and lend expression to his religious conviction. The peace
and harmony of his life in La Colline with his second wife Vava, and the
powerful light in the south of France, provided the perfect conditions for
this challenging work. "Stained-glass windows have simple prerequisites
– matter and light," Chagall noted, "and the same phenomenon applies
to both cathedrals and synagogues: something mystical penetrates the
window."

The stained-glass window *Peace* in the United Nations Building in New York was made in 1964 to commemorate Dag Hammarskjöld, the Secretary General of the United Nations and his colleagues, who were killed on 17 September 1961 in an aeroplane crash in Africa. This massive work of art, which measures 358 x 538 cm, was inaugurated on 17 September 1964 and represents one of Chagall's late stained-glass windows. The composition, inspired by the Hebrew prophet Isaiah, has powerful musical undertones and is considered by many to be one of the most important windows that Chagall created.

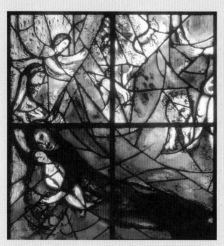

First of all Chagall made a gouache sketch to ensure that the structure of the composition was balanced down to the smallest detail. The work is divided into two: on the left, humans and animals are living in a world to which peace has returned after God's intervention, while on the right, a crowd has gathered around the base of the cross. At the centre of the composition are the small figures of Adam and Eve surrounded by flowers. A deeper blue on the right and a visibly lighter blue on the left differentiate the two worlds. The right half is densely packed with figures and details which fill the space, whereas on the left the figures are caught up in a harmonious, dance-like, swirling movement. Regarded as a whole, it is an unusually powerful and dynamic composition. Our eyes wander automatically in a wide circle within the left-hand half of the window, starting at Adam and Eve and moving clockwise past the upright snake, the Virgin and Child, a number of Biblical figures and the Mourning of Christ. This circle encloses a space in which the newly reconstituted peace on Earth is being celebrated. The rounded back of the prophet in the right half, further emphasizes the composition's rhythmic movement.

To construct the window Chagall relied on the technical support of the stained-glass artist Charles Marq. He was fortunate indeed to have been introduced to Marq who put his vast technical expertise at Chagall's disposal without imposing on the artist's designs. The artist and the glass-maker would both discuss the choice

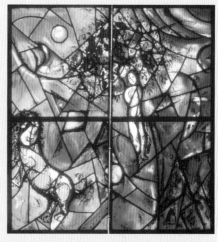

of glass and the colours to be used and, once the technicalities had been finalized, Chagall would make minor adjustments to the design.

Windows created by Chagall and Marq can be found in Israel, America, England, France, Germany and Switzerland. In 1957, Chagall worked on murals and stained-glass windows for a church in Assy, France. This was followed by a number of windows for Metz Cathedral (the first window was completed in 1960) and Reims Cathedral (1974). Other major works include windows at the Art Institute of Chicago, the synagogue of the Hebrew University Hadassah Medical Centre in Jerusalem (*The Tribe of Levi*, 1960–62) and stained-glass windows for Zurich Minster.

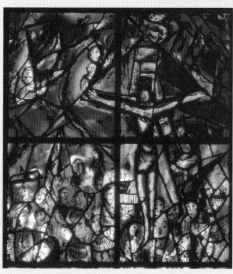

Where can Chagall's works be seen?

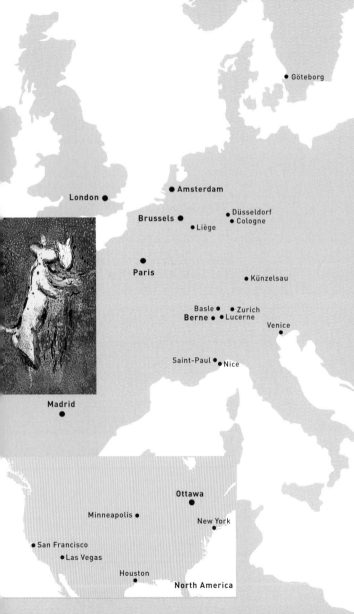

Göteborg

London ● ● Amsterdam

Brussels ● ● Düsseldorf
● Liège ● Cologne

● Paris

● Künzelsau

Basle ● ● Zurich
Berne ● ● Lucerne

Venice ●

Saint-Paul ● ● Nice

Madrid ●

Ottawa ●

Minneapolis ●

New York ●

● San Francisco
● Las Vegas

Houston ●

North America

St Petersburg

Moscow

Nagoya

Osaka

Japan

Tel Aviv

A selection of museums housing some of Chagall's most famous works:

Amsterdam
Stedelijk Museum of
Modern Art
Paulus Potterstraat 13
www.stedelijk.nl

Basle
Öffentliche Kunstsammlung
Basel, Kunstmuseum,
Sankt-Alban-Graben 16
www.kunstmuseumbasel.ch

Berne
Kunstmuseum Bern
Die Sammlung Im Obersteg
Oberhofen am Thunersee
www.kunstmuseumbern.ch

Brussels
Musées royaux des Beaux-Arts
de Belgique, Le Musée d'Art
Moderne
9, rue du Musée
www.fine-arts-museum.be

Cologne
Museum Ludwig
Bischofsgartenstraße 1
www.museum-ludwig.de

Düsseldorf
Kunstsammlung
Nordrhein-Westfalen
K20 Kunstsammlung am
Grabbeplatz
Grabbeplatz 5
www.kunstsammlung.de

Göteborg
Göterborgs Konstmuseum
Götapl
www.konstmuseum.goteborg.se

Houston, Texas
Museum of Fine Arts
1001 Bissonnet Street
www.mfah.org

Künzelsau
Museum Würth
Reinhold-Würth-Straße 15
www.wuerth.com
www.swo.de/wuerth

Madrid
Museo Thyssen-Bornemisza
Paseo del Prado 8
www.museothyssen.org

Las Vegas
Guggenheim Hermitage
Museum
3355 Las Vegas Boulevard
South
www.guggenheimlasvegas.org

London
Royal Academy of Arts
Burlington House
www.royalacademy.org.uk

Tate Modern
Bankside
www.tate.org.uk

Liège
Musée d'Art Moderne et d'Art
Contemporain
3, parc de la Boverie
www.mamac.org

Lucerne
Sammlung Rosengart Luzern
Pilatusstraße 10
www.rosengart.ch

Minneapolis, Minnesota
Minneapolis Institute of Arts
2400 3rd Avenue South
www.artsmia.org

Moscow
Pushkin Museum of Fine Arts
Ulitsa Volkhonka 12
www.museum.ru/gmii

Tret'yakov Gallery
Lavrushinsky pr 10
www.tretyakov.ru

Nagoya
Nagoya-shi Bijutsukan
(Nagoya Museum of Art)
2-17-25 Sakae, Naka-ku
www.art-museum.city.nagoya.jp

New York
Solomon R. Guggenheim
Museum
1071 5th Avenue at 89th Street
www.guggenheim.org

The Museum of Modern Art
11 West 53 Street
www.moma.org

Nice
Musée national Message
Biblique Marc Chagall
Avenue Docteur Ménard
www.musee-chagall.fr

Osaka
The National Museum of Art
10–4 Expo Park
Senri Suita
www.nmao.go.jp

Ottawa, Ontario
National Gallery of Canada
380 Sussex Drive
www.national.gallery.ca

Paris
Musée national d'Art Moderne,
Centre Georges Pompidou
19, rue de Renard
(Entrance: Place Georges
Pompidou)
www.centrepompidou.fr

Saint-Paul
Fondation Maeght
623, Chemin des Gardettes
www.fondation-maeght.com

San Francisco
Fine Arts Museums of
San Francisco
34th Avenue and Clement Street
www.thinker.org

St Petersburg
I. Brodsky Museum
www.brodsky.spb.ru

State Hermitage Museum
34 Dvortsovaya Naberezhnaya
www.hermitagemuseum.org

State Russian Museum
Stroganov Palace
Nevskij pr 17
www.rusmuseum.ru

Tel Aviv
The Tel-Aviv Museum of Art
27, Shaul Hamelech Boulevard
www.tamuseum.com

Venice
Peggy Guggenheim Collection
Pallazzo Venier dei Leoni
www.guggenheim-venice.it

Zurich
Kunsthaus Zürich
Heimplatz 1
www.kunsthaus.ch

More about Chagall: a selection of books on the artist and his works

Literature on Marc Chagall and his work is just as multifaceted and extensive as his œuvre itself.

Charles Sorlier (ed.), Chagall by Chagall, New York 1979 and Marc Chagall, Life and Work, New York 1964, written by Chagall's son-in-law Franz Meyer, are still regarded as major **standard works on the artist**.

Books providing a **useful overview with a biographical narrative** include: Jacob Baal-Teshuva, Marc Chagall 1887–1985, Cologne 1998; Walter Erben, Marc Chagall, Munich 1957, which includes a number of conversations with the artist (2nd revised edition, 1966) and Roland Doschka, Marc Chagall – Origins and Paths, exhib. cat., Munich et al. 1998.

Among the many **catalogues raisonnés** available, the following can be recommended: Franz Meyer and Hans Bolliger, Marc Chagall, The Graphic Work, New York 1957 and Eberhard W. Kornfeld, Verzeichnis der Kupferstiche, Radierungen und Holzschnitte von Marc Chagall, Berne 1970. Ulrike Gauss, Marc Chagall, Die Lithographien, La Collection Sorlier, exhib. cat., Ostfilden 1998, reproduces 1,050 lithographs from the collection created by Charles Sorlier who, from 1950 onwards, printed Chagall's work in the Atelier Mourlot in Paris. This volume also includes an interesting interview with the stained-glass expert Charles Marq. Charles Sorlier and Fernand Mourlot themselves are the editors of a six volume catalogue raisonné on the lithographs which was published between 1960–86 by André Sauret in Monte Carlo.

The artist's own writings provide a glimpse of his thoughts and ideas: Ma Vie, translated from the Russian by Bella Chagall, Paris 1931 (English translation: London 1967); Mein Leben (with 20 original

etchings), Berlin 1923 and Poèmes, with 24 coloured woodblock prints, Geneva 1968. Graphic works by Chagall can be found in: Nikolai Gogol, Les Âmes Mortes, translated from the Russian by Henri Mongault, 2 vols., with 107 etchings, Paris 1948; Jean de la Fontaine, Fables, Eaux-Fortes Originales Marc Chagall, 2. vols., Paris 1952; Longos, Daphnis and Chloe with lithographs by Marc Chagall, Munich et al. 1994 and Marc Chagall, Arabian Nights, with an introduction by Norbert Nobis, Munich et al. 1988, with 13 colour lithographs.

Well documented, **art-historical information on specific areas** of Chagall's work, combined with highly readable cultural histories and excellent illustrated material can be found in: Christoph Vitali (ed.) Marc Chagall: Die Russischen Jahre, 1906–1922, exhib. cat., Berne 1991; or Susan Compton, Marc Chagall: My Life – My Dream, Berlin and Paris 1922–1940, Munich et al. 1990, which reproduces the etchings and gouaches side by side. One of the few books on Chagall's ceramic works is: Roland Doschka (ed.), Marc Chagall: Ceramic Masterpieces, Munich et al. 2003, which includes a large number of otherwise un-known objects from a major private collection. An excellently illus-trated book on Chagall's stained-glass windows is: Sylvie Forestier, Marc Chagall: Seine Farbfenster aus aller Welt, Stuttgart 1995.

Books in Prestel's 'Adventures in Art' series are not just for children, but provide an interesting insight into the artist's work, together with a selection of excellent illustrations: Marc Chagall: What Colour is Paradise, Munich et al. 2000; and Life is a Dream, Munich et al. 1998. A fascinating, easy-to-read book by Howard Greenfeld, who knew Chagall personally, is: Marc Chagall, New York 1990.

And for all those who would like to share their enthusiasm for Chagall and his art: Marc Chagall, Prestel Postcard Book, Munich et al. 2003.

Marc Chagall: Self-Portraits and Photographs of the Artist

At all stages of his artistic career Chagall painted self-portraits and pictures in which he featured himself, at least in part. These works vary from simply sketched drawings comprising a few lines to intricately constructed paintings such as *Self-Portrait with Seven Fingers* (1912–13). In this work, as in many other instances, his portrait includes attributes

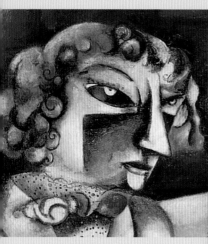

alluding to his childhood, or to places such as Vitebsk or Paris which influenced his way of thinking and working. Chagall also picked up on the age-old tradition of depicting himself with the tools of his trade – a palette, brushes and easel – something found in the work of artists in the Renaissance. After meeting Bella, Chagall clearly showed his happiness in works such as *The Birthday*, *Double Portrait with Wine Glass* and *The Stroll*, which are really very personal portraits of the couple.

Amusingly, he included just his face in some works, too, such as in *Paris through the Window*, where he transposed his profile onto the cat's. In *Introduction to the Jewish Theatre* he boldly placed himself in the limelight and let himself be carried into the scene. His gouache *Large Face – Self-Portrait with Large Yellow Face* from 1969 is different in style from most of his other portraits. Bearing in mind he was already eighty-two when he painted this work, he depicted himself with a surprisingly youthful face and made colour the most important element, with blues and yellows spreading across the work.

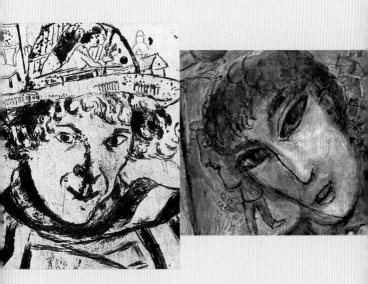

Chagall's life was well documented in photographs, including a surprising number of pictures of him as a boy or with his relatives and friends. In the second half of the twentieth century, there are of course any number of photographs recording meetings with other artists or taken when visiting exhibitions, as well as pictures showing him at work on sketches, ceramics or designs for stained-glass windows. Such pictures render the artistic process visible and define our image of Chagall as a person and as an artist.

Collage A picture made up of different objects and materials such as newspaper glued to a surface and often combined with painting. It was invented by the Cubists Braque and Picasso and was widely used in twentieth-century art.

Engobe A creamy clay mixture used to coat a ceramic vessel, thus making it waterproof. It is usually a different colour from the work and can, therefore, also be used to decorate the piece.

Etching The process of making a design on a metal plate (usually copper). The plate is covered with an acid-resistant coating and the design drawn using a needle to expose the plate beneath. The plate is then immersed in an acid bath where the acid eats into the exposed metal. The longer the acid is allowed to be in contact with the metal, the deeper the lines become. The process can be repeated, each time 'stopping out' those parts that should remain unaltered with an acid-resistant material. The plate is then cleaned and inked for printing. An etching is always the mirror-image of the original design. The first dated etching is from 1513, but the heyday of this medium was in the seventeenth century.

Expressionism A term first coined by Herwarth Walden to characterise all modern art that was opposed to Impressionism, especially the works of German artists at the beginning of the twentieth century. The movement began with the founding of the Brücke group in Dresden in 1905 (incl. Kirchner, Heckel and Schmidt-Rottluff, later Nolde and Pechstein), reached its peak in the Blauer Reiter (incl. Kandinsky, Marc, Macke and Klee) before World War I, and declined in the 1920s. The Expressionists deliberately ignored academic technical standards, emphasizing instead the inevitability of artistic expression.

Gouache An opaque watercolour paint (or poster paint) containing a gum binder with a filler of some form of opaque white (such as clay). This lends the material its typically chalky look. As it is easier to handle than oils, it is often used for studies for large

oil paintings, although it dries lighter than when applied.

Lithograph A print made by drawing with greasy chalk on a fine-grained, porous limestone slab or zinc plate. In a laborious process the stone or plate is then wettened before greasy ink is applied which only adheres to the lines drawn, leaving the wet areas uninked. The process was invented in 1798 and was particularly popular in the nineteenth century. It is still used widely today. There is virtually no limit to the number of prints it is possible to make.

The Nabis A group of mainly French artists founded in Paris in 1889 (incl. Bonnard, Vuillard and Vallotton) who liberated themselves from conventional perspective, favouring intimate interiors with a mysterious atmosphere.

Salons The **Salon d'Automne** was an art exhibition first held in 1903 in the Grand Palais in Paris aimed at presenting trends in contemporary painting. Held annually in October or November, it remained important until well into the 1950s and was famous for exhibiting works by Matisse, Cézanne, Delaunay and Léger. The **Salon des Indépendants** was founded in 1884 and was directed more towards neo-Impressionism. Works by Cubist, Orphist and Futurist artists were exhibited up until 1914, by which time the Salon d'Automne had become more important.

Der Sturm 'The Storm' was a magazine founded in 1910 by Herwarth Walden who also established a gallery in Berlin of the same name in 1912. Walden began by showing works by the Blauer Reiter group of artists, the Italian Futurists and other avant-garde artists, including Chagall. Most significantly, Walden was instrumental in providing a platform for the German Expressionists.

Tempera an emulsion used as a medium for a pigment, traditionally (but not ex-clusively) made with eggs. It dries extremely quickly and was widely used by Italian painters in the fourteenth and fifteenth centuries for fresco painting.

© 2004 Prestel Verlag, Munich · Berlin · London · New York

Front cover: **Large Face – Self-Portrait with Large Yellow Face** (detail),
1969, see also front flap and p. 47
Back cover: **The Fiddler** (detail), 1912–13 , see also p. 13

Photographic credits: cover, pp. 47, 27, 63 bottom: private collection _
pp. 5, 13, 39 l., 63 centre: Stedelijk Museum Amsterdam _ pp. 7, 34:
courtesy Katz Collection, Milwaukee, Winsconsin _ p. 9: courtesy Sinaida
Gordejewa Collection, St Petersburg _ p. 10: State Russian Museum, St
Petersburg _ pp. 14, 28/29: courtesy Tret'yakov Gallery, Moscow _ p. 15:
Solomon R. Guggenheim Museum, New York _ pp. 16, 22: Artothek,
Weilheim _ p. 24: courtesy I. Brodsky Museum, St Petersburg _ pp. 25, 36
r., 63 top: courtesy Museo Thyssen-Bornemisza, Madrid _ pp. 19 bottom,
56 l.: © André Ostier _ p. 7: Museum Ludwig, Cologne _ pp. 6, 49: Ida
Chagall Archive, Paris _ pp. 33, 41 bottom: The Tel Aviv Museum of Art _
p. 35: Franz Meyer Archive _ p. 37: courtesy Herbert Black Collection,
Canada _ p. 38 l.: Galerie Rosengart, Lucerne _ pp. 23 r., 26, 39 r., 54:
Musée national d'Art Moderne, Centres Georges Pompidou, Paris _ p. 40:
The Art Institute of Chicago _ p. 41 top: © Lipnitzki, Paris _ pp. 45, 50,
57: Musée national Message Biblique Marc Chagall, Nice _ p. 48: Kunst-
haus Zürich, Zurich _ p. 51: courtesy Fondation Marguerite et Aimé
Maeght, Saint-Paul _ p. 52 top l.: courtesy Yves Lebouc _ p. 52 top r.:
Ewald Graber, Bern / Archives Marc Chagall, Paris _ p. 52 bottom: RA-
Gamma Liaison / Frank Spooner Pictures, London _ p. 55 bottom: J.F.
Amelot, Seilnac _ pp. 58/59: United Nations Photographic and Exhibition
Section _ map flap, top l.: Archives Marc Chagall

The Library of Congress Cataloguing-in-Publication data is available;
British Library Cataloguing-in-Publication Data: a catalogue record for
this book is available from the British Library; The Deutsche Bibliothek
holds a record of this publication in the Deutsche Nationalbibliografie;
detailed bibliographical data can be found under: http://dnb.ddb.de

Prestel Verlag, Königinstrasse 9, 80539 Munich
Tel. +49 (89) 38 17 09-0; Fax +49 (89) 38 17 09-35

Prestel Publishing Ltd., 4 Bloomsbury Place, London WC1A 2QA
Tel. +44 (020) 7323-5004; Fax +44 (020) 7636-8004

Prestel Publishing, 900 Broadway, Suite 603, New York, NY 10003
Tel. +1 (212) 995-2720; Fax +1 (212) 995-2733

www.prestel.com

Series concept: **Victoria Salley**
Graphics: **www.Lupe.it**, Bolzano, Italy

Edited by **Rosie Jackson**, Munich
Designed and typeset by **Lachenmann Design**, Munich
Originations by **Reproline Genceller**, Munich
Printed and bound by **Gotteswinter**, Munich

Printed in Germany on acid-free paper
ISBN 3-7913-3074-8